DIRECTOR'S CHOICE
THE LIBRARY OF
TRINITY COLLEGE
DUBLIN

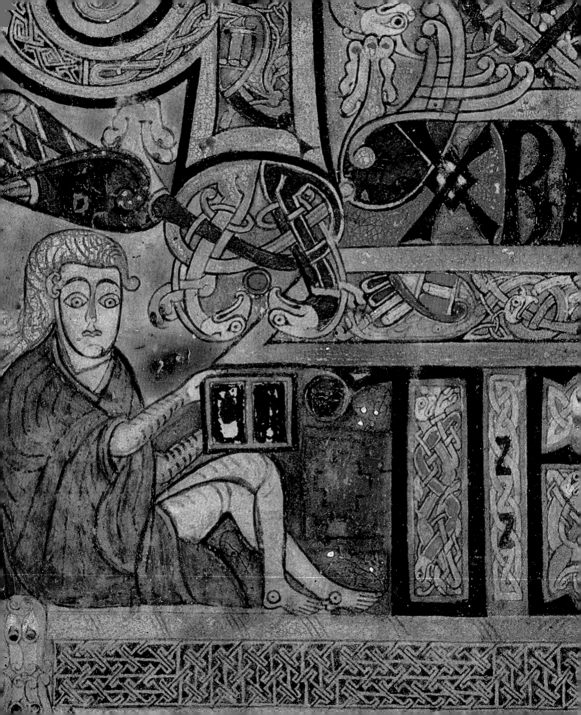

THE LIBRARY OF TRINITY COLLEGE DUBLIN

Helen Shenton

SCALA

INTRODUCTION

PERHAPS THIS BOOK should really be called 'Director's Dilemma'. How to do justice to the breadth, depth and variety of the magnificent collections in the Library of Trinity College Dublin, amassed over four centuries since the foundation of the university in 1592 by Queen Elizabeth I?

The Library has developed over the centuries through a combination of generous donations, acquisitions and legal deposit.

In its first two centuries the Library's growth was heavily reliant on benefactions – its greatest treasures, the Book of Kells and Book of Durrow were presented by Henry Jones, bishop of Meath and vice-chancellor of the university in the 1660s.

The purchase of the pan-European Fagel collection in 1802 by the governors of the Erasmus Smith Schools in Dublin on behalf of Trinity College transformed the Library, increasing its total holdings by some 40 per cent.

The Library was endowed with legal deposit privilege in 1801 and continues to receive material published in the UK on behalf of Ireland. Legal deposit material accounts for much of the Library's printed collection, and since 2013, the Library has been acquiring UK electronic legal deposit material. Trinity College Dublin also benefits from Irish legal deposit material.

There are currently some 6.5 million books, 800 medieval manuscripts, 250,000 early printed books, 800,000 maps, 145,000 electronic journals, 850,000 e-books and 19 million UK websites in the Library. These astounding collections weave through 3,000 years of creativity, memory and knowledge.

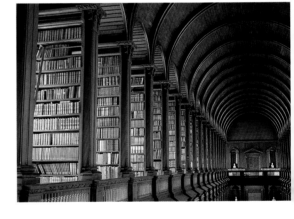

Long Room Gallery, Old Library, Trinity College Dublin

Around the world, the Library of Trinity College Dublin is best known for the Book of Kells, the exquisitely decorated, early ninth-century manuscript of the four gospels. In 2018 more than one million people came to

see this national treasure and to visit the Old Library's 'Long Room', frequently described as 'the most beautiful room in Ireland'.

The Book of Kells has always been celebrated for its beauty; its repertoire of intricate patterns and enigmatic symbols is instantly recognisable as Irish. Indeed, this early Christian manuscript has become so synonymous with Irish culture that its decorative motifs have appeared on everything from the Irish five-pound note to Riverdance costumes and Irish passports.

Originally bound in one volume and housed in an ornamental binding or box-shrine, the Book of Kells has been rebound several times during its 1,200-year history. In 1953 the British Arts and Crafts bookbinder and innovative conservator, Roger Powell OBE (1896–1990), rebound the gospels into four individual volumes. I had the privilege of being Powell's last assistant, during which period I spent time in Trinity's Conservation Department. So there is a delightful circularity in now having the honour of being Librarian and College Archivist at Trinity College Dublin.

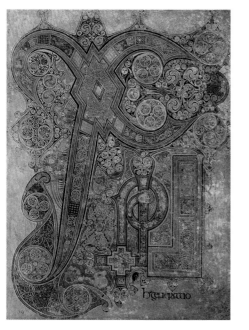

Chi Rho page, Book of Kells, folio 34r

Which brings me back to the Director's Dilemma. From Egyptian Books of the Dead made from papyrus to Samuel Beckett's minimalist postcards; from Dean Jonathan Swift's death mask to the elegantly hand-written drafts of John Banville's recent novel; from Oscar Wilde caricatures to J. M. Synge's typewriter; from exquisite herbaria and Terry Pratchett novels to the marriage certificate of James III; from performance art within the Berkeley Library to the 'Pomodoro Sphere' sculpture on the piazza outside; from the Book of Durrow to correspondence between Michael Collins and Winston Churchill… I offer the following choices from the extraordinary collections of the Library of Trinity College Dublin.

Books of the Dead
Egypt, New Kingdom, 1550–1069 BCE
Shelfmark: TCD MS 1661/1

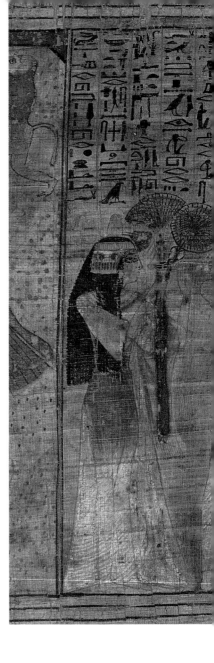

THE LIBRARY OF TRINITY COLLEGE DUBLIN holds many surprises and one of them is a small but fascinating collection of Egyptian papyri, gifted to College in 1838, which includes some notable Books of the Dead. These scrolls were commissioned by individuals in preparation for their dangerous journey through the underworld to eternal life. They contain spells, incantations and illustrations to help these individuals attest to a virtuous life when challenged at the various gateways along the way, and to soothe the hostile creatures they would encounter. This detail is from the most beautifully decorated example in the collection, measuring an impressive 175 x 35 cm. Here the owner of the book, together with his wife, faces the Everlasting Devourer – a fantastical beast with the hindquarters of a hippopotamus, the body of a leopard, the head of a crocodile and the power to end their journey in one snap of his jaws. Emerging from the papyrus behind the Devourer is the goddess Hathor in her bovine form; the female counterpart to the sun god Ra, she is often represented as a cow with a sun disc between her horns. As a more benevolent deity, Hathor had the power to pass through the boundary separating the living from the *Duat* – the realm of the dead. The name of the book's owner has not been recorded in the hieroglyphic text, however, the quality of the exquisite vignettes indicates that he was a wealthy individual.

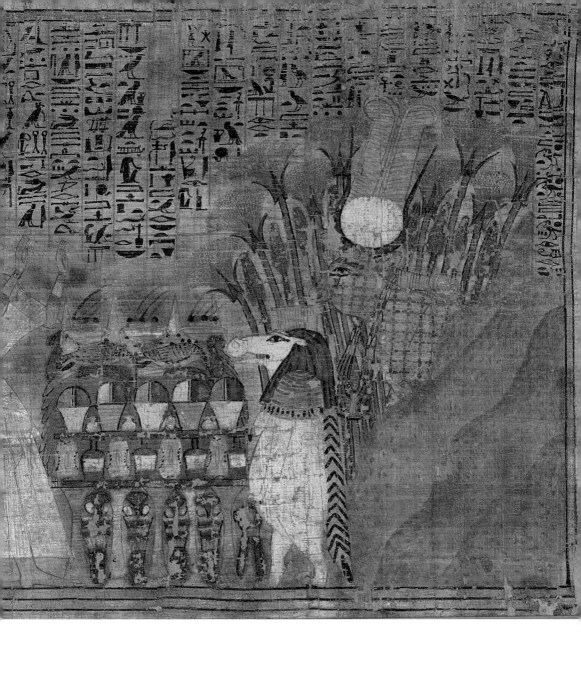

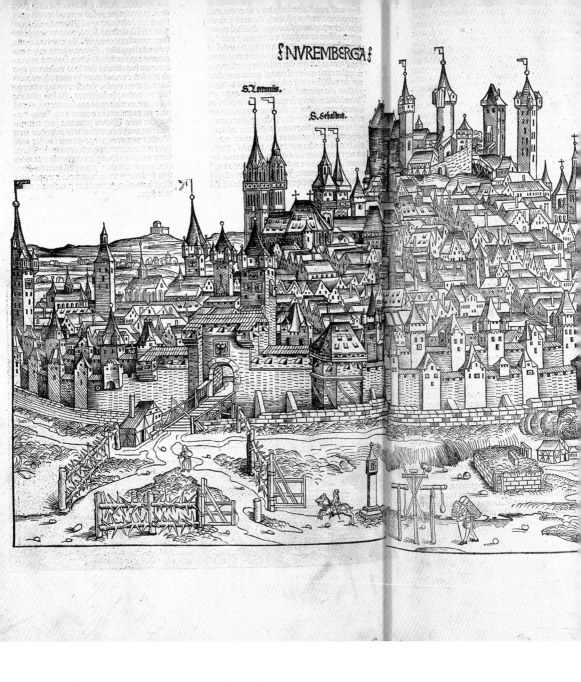

HARTMANN SCHEDEL
(1440–1514)

Nuremberg Chronicle
Nuremberg, 1493

Shelfmark: N.bb.1.

HARTMANN SCHEDEL's *Liber Chronicarum*, also called the *Schedelsche Weltchronik*, is better known as the *Nuremberg Chronicle*. This wonderfully illustrated book, which includes no fewer than 1,809 woodcuts from 645 blocks, is the most famous woodcut-illustrated book in history. It bears this honour not only because of its extensive illustrations, but also for its intriguing merging of text and image.

The *Nuremberg Chronicle* is a fitting name because the driving force in its creation was a small but determined group of citizens of the imperial city of Nuremberg in southern Germany. Its author Hartmann Schedel was a learned humanist who wished to produce a chronicle of world history that would reflect his scholarship. It was very much a collaborative affair, bringing together a group of people to work on this ambitious Renaissance project. Crucially it gained the backing of a leading Nuremberg merchant and humanist, Sebald Schreyer (1446–1520), and his brother-in-law Sebastian Kammermeister (1446–1503), a fellow merchant. Their financial support ensured that the project was taken on by the influential Nuremberg printer Anton Koberger (c.1440–1513), and illustrated by two leading artists based in Nuremberg, Michael Wolgemut (1434–1519) and Wilhelm Pleydenwurff (c.1450–94).

The result is a joyous mixture of humanist scholarship, wonderful printing and amazing book design which reflect the aspirations and ambitions of Nuremberg humanists during the Renaissance. The Library of Trinity College Dublin is fortunate to possess the first edition of 1493 and the pirated Augsburg edition of 1497.

(Isaac) Robert Cruikshank
(1789–1856)

A new Irish jaunting car, the dandy's hobby, the velocipede,
or the perambulator, by which you can ride at your ease &
are obliged to walk through the mud at the same time
London, 1819

Shelfmark: OLS CARI-ROB 157

This hand-coloured etching by caricaturist Robert Cruikshank from the Nicholas K. Robinson Collection in the Library of Trinity College Dublin satirises the precursor to the bicycle – the dandy's hobby or velocipede. Initially designed by prolific inventor Karl Drais and in vogue for a short period up to 1820, the contraption was unfortunately impractical for everyday use, as the print clearly shows. Printmakers had been quick to record its popularity, with the first of many velocipede-themed prints published in January 1819. Its attractiveness to aspiring gentlemen (dandies) can be attributed to Denis Johnson (c.1760–1833), who improved on the Drais design and ran cycling schools in London to instruct owners in its use.

The nineteenth century saw further progression in the development of the bicycle, with both tri- and bi-cycling gaining popularity. Organisations such as the Cyclists' Touring Club and the Irish Cycling Association were formed to promote cycling both as a sport and as a leisure pursuit. The financial cost and the practicalities of storing a cycle made ownership unfeasible for most people. However, with the aid of improvements in design, reduced costs and increased investment in road surfaces, cycling eventually gained universal popularity, thus helping to make it the affordable, enjoyable and environmentally friendly mode of transport that it is today.

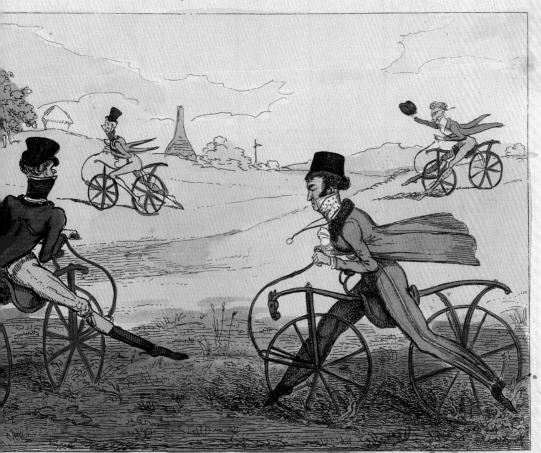

1819.

Jaunting Car, the Dandy's Hobby, the Velocipede, or the Perambulator,
ride at your Ease & are obliged to Walk in the Mud at the same time.

London Published by S.W. Fores 50 Piccadilly

Oscar Wilde
(1854–1900)

The Oscar Wilde Collection

Shelfmark: TCD MS 11437/2/1/2 (Sarony portrait);
TCD MS 11437/5/1, 3 trade cards)

KNOWN FOR HIS BITING WIT, FLAMBOYANT DRESS and glittering conversation, Oscar Wilde was one of the most famous Irish personalities of the nineteenth century and one of the great writers of the Victorian era. He is also one of Trinity College Dublin's most celebrated alumni. Besides his literary accomplishments, Wilde became a figure of some notoriety for his lifestyle and involvement in the 'art for art's sake' aesthetic movement, as well as the circumstances of his imprisonment and early death.

 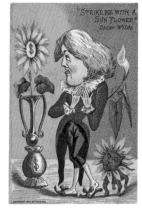

The Library's Oscar Wilde Collection is the only Wilde archive held in a public institution in Ireland and is unique in its focus on the playwright's downfall and exile. It comprises items of symbolic significance, such as a receipt for a loan of money Wilde received on leaving Reading Gaol in 1897, and the only known letter written to his son, Cyril.

The collection was the focus of a major exhibition in the Library of Trinity College Dublin in 2017 entitled *Oscar Wilde: From Decadence to Despair*. This photograph of Wilde was perhaps the most iconic exhibit. Shortly after his arrival in New York for his 1882 lecture tour, Wilde posed for a series of photographs taken by Napoleon Sarony, then the most famous portrait photographer in America.

The Oscar Wilde trade cards above, titled *National Aesthetics*, were printed by E.B. Duval of Philadelphia to coincide with this famous 'aesthetic tour' and were hugely popular.

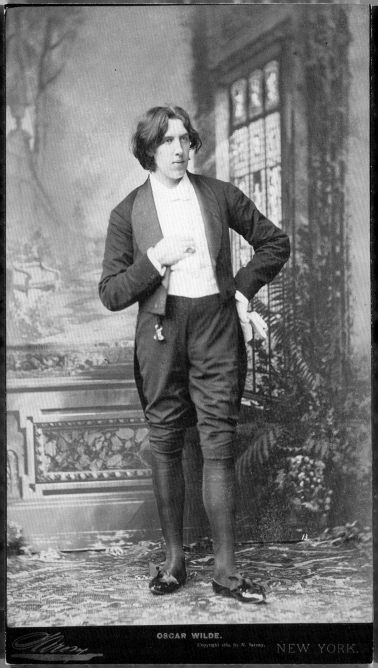

OSCAR WILDE.
Copyright 1882 by N. Sarony.

NEW YORK

Book of Durrow
*c.*650–700
Shelfmark: TCD MS 57 folio 21v (image of Matthew)

THE BOOK OF DURROW IS THE BEAUTIFUL, if more restrained, precursor of the Book of Kells. Although the scale and intricacy of these two magnificent gospel books differ significantly, their shared artistic lineage is clear. The Book of Durrow's simple palette of colours – red, yellow and green – fills entire 'carpet' pages with dizzying ornamentation. The Evangelist symbols, in contrast, stand out on the page against a void of creamy vellum, their isolation framed by bands of interlace. Those who have had the privilege of seeing the Book of Durrow on display are invariably struck by the extraordinary quality of the Book's production. In using fewer colours and less elaborate motifs, the Book of Durrow presents a refined and concise symbolism of the Word of God.

Detail from the portrait of Matthew

The Book of Durrow is interesting as it presents the four Evangelists in a different way from how the Book of Kells would 100 years later. In the Book of Kells, the four Evangelists (Matthew, Mark, Luke and John) are represented by the symbols of man, lion, calf and eagle respectively, in accordance with the Latin Vulgate version of the gospels prepared by St Jerome in the late fourth century CE. The Book of Durrow, however, follows the pre-Vulgate version where the lion represents John and the eagle, Mark.

As with any book or object that is 1,300 years old, the Book of Durrow's survival is truly remarkable – and its fascination has not dimmed.

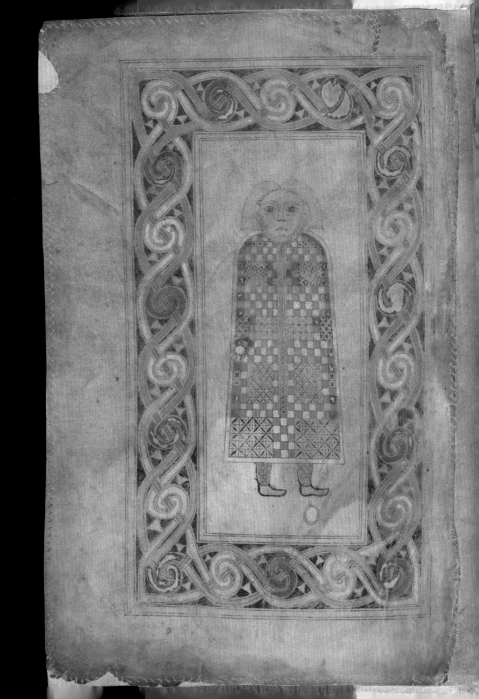

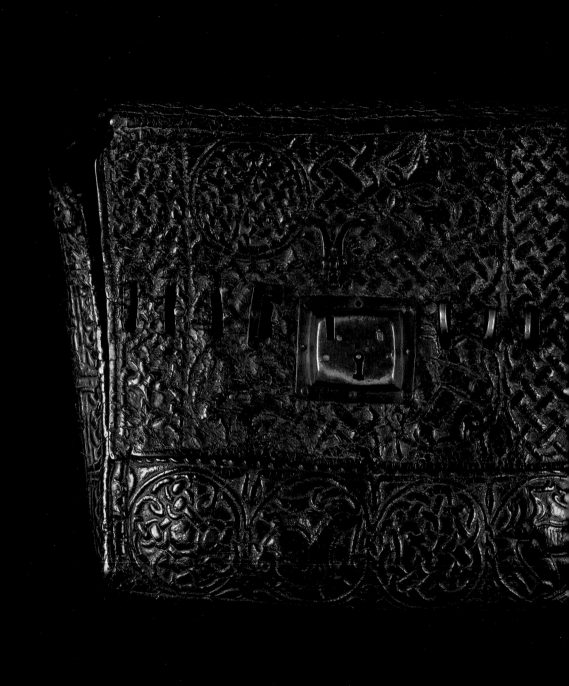

The Armagh Satchel

Shelfmark: TCD MS 52***

THE ARMAGH SATCHEL IS, as the name suggests, associated with a ninth-century manuscript, the Book of Armagh. The manuscript has strong provenance: its colophon tells us it was partially scribed and illuminated by Ferdomnach for Torbach, the abbot of Armagh, in the year 807 CE. The satchel remains more of an enigma, little commented on over the centuries. Its dating has been contentious, with different schools of thought placing it from the early ninth century to as late as the fifteenth century. The decoration harks back to the early medieval 'Golden Age' of Irish art, with every surface of the thick cow hide covered in interlace, zoomorphic features and crosses. The construction method is called *cuir-bouilli*: the saturated leather is worked over a form, possibly even damp sand, with the pattern shaped using bone or wooden tools. A brass lock and a line of brass loops, presumably for a rod to lock the large flap in position, were added later as supplementary 'bling'. The satchel was constructed from a single piece of thick cow hide. The pattern-shaping and stitching were very skilful, with the edges turned in so no seam was visible. This was no mean feat given the unyielding nature of thick hide, made even more rigid by its saturation and drying during the decoration process.

Satchels were generally not tailor-made but were more 'off-the-shelf' book containers. The Armagh Satchel has an internal capacity of about 300 x 250 x 40 mm, which could easily accommodate the diminutive Armagh manuscript.

Correspondence between Michael Collins and Winston Churchill
May–August 1922

Shelfmark: TCD MS 11399

IRISH REPUBLICAN GENERAL MICHAEL COLLINS and British cabinet minister Winston Churchill had occupied opposite positions during the War of Independence; both had been signatories of the Anglo-Irish Treaty in December 1921; and both now found themselves in an uneasy 'alliance' in trying to progress Irish independence. The Treaty, and the subsequent choice by Northern Ireland to withdraw from the Irish Free State, precipitated the Irish Civil War.

This file documents the communications between Collins (then Chairman of the Provisional Government of the Irish Free State) and Churchill, between May and August 1922, the dramatic period between the sparking of the Civil War and Collins' assassination.

In many ways they fulfil their stereotypes: Collins the military man, brief, direct and literal, and Churchill, the wily politician with a gift for soundbites and hyperbole.

Collins telegraphed Churchill requesting ammunition during the first engagement of the Irish Civil War, the battle of the Four Courts, in June 1922. On 29 June Collins wrote ' We were promised two hundred rounds of high explosives at two A.M. this morning but they were not available… the effect of this is to create great lack of confidence on our side amounting to grave suspicion'. Churchill, who was endeavouring to ensure that British forces still in Ireland assisted Collins' pro-Treaty forces, expressed his concern for Collins in this postscript; 'I hope you are taking good care of yourself and your colleagues. The times are v. dangerous'.

In the final letter, dated 4 August 1922, Churchill signed off with 'I hope that by the time I return in the latter part of August you will have seen that the Irish people are masters in their own house'. Collins died at Béal na Bláth, Cork, on 22 August, less than three weeks later.

7th July, 1922.

Mr. Collins,

have not troubled you during these anxious days
fined my messages to your practical requirements.
ts which have taken place since you opened fire
Courts seem to me to have in them the
s of very great hope for the peace and ultimate
land, objects both of which are very dear to your
ignatories. I feel this has been a terrible
ou and your colleagues, having regard to all
pened in the past. But I believe that the action
en with so much resolution and coolness was
e if Ireland were to be saved from anarchy and
rom destruction. We had reached the end of our
here at the same time as you had in Ireland. I
ve sustained another debate in the House of
he old lines without fatal consequences to the
erning instrument in Britain, and with us the
have fallen too. Now all is changed. Ireland
ress in her own house and we over here are in a
q.

further your

uthority of the
, as I do not
aced yourself and
ss of the Irish
peful than any we
the objective must
is can be achieved
towards which we
e tremendous
d no doubt any
t I have a strong
en reached, and that
ture than in the past.
gth and advantages
lutions. Minor
t not be allowed to
 Craig and Londonderry
have not worried them
which are undoubtedly
of the 28th June. The

ehing Proportional
Royal Assent, which
t it all over. Other-
in the hopes of a
the governing idea of
how Mr Griffith wrote
. There is the key
l the right moment
tages by premature
e seen Craig and
etter result in
omplaints than by

ing with revolt
in your mind
ould make for
mperial point
than to see
ssembly without
ach ideas would
moment, but
very quickly.

ed on a
things
people
ces die
and adjust
two may

and show

with.

good
agues.
unes.

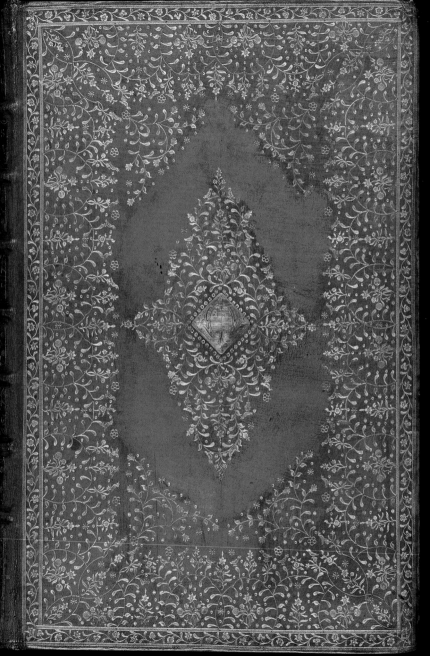

Baskerville Bible
Cambridge, 1763
Shelfmark: Armoire

THE COPY OF THE BIBLE KNOWN FAMILIARLY as the 'Baskerville Bible' was printed by the English printer John Baskerville in 1763. The productions of his press are revered by bibliophiles for the beauty of the type and for the pleasing, spacious layout of the pages. Baskerville's folio edition of the Bible was one of his largest projects and a fine example of the excellence of his printing. Such a beautiful printed book deserves a beautiful binding and that is just what the copy belonging to the Library of Trinity College Dublin was given.

According to evidence from the tools used, this copy of the Baskerville Bible was probably bound at William Hallhead's bindery in Dublin in around 1775. The binding was commissioned by the book's owner, Sir Richard Cox of Dunmanway in County Cork, whose arms are present on a small brass plaque on the upper cover. The volume was later acquired by the Irish bibliographer E.R. McClintock Dix, author of many works about early Irish printing, who presented it to the Library in 1907.

During the second half of the eighteenth century there were several bookbinders working in Dublin who produced exceptionally fine decorated bindings. Trinity College's Bible is one of the most outstanding examples of their work. Bound in full red Morocco leather, the covers and spine are a mass of gold-tooled decorations, each one of them expertly and precisely stamped by hand onto the leather.

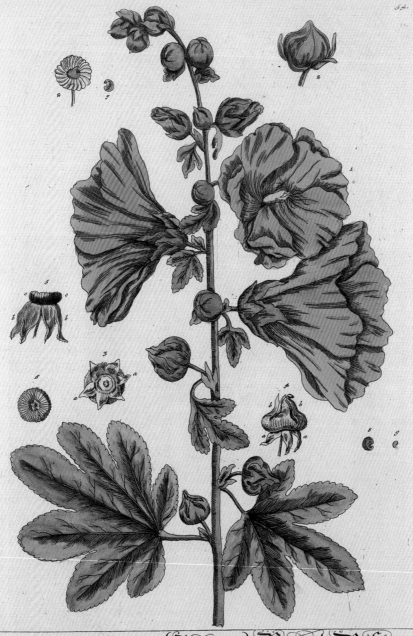

Malva arborea. 1. Blume. 2. 3. 4. 5. 6. Frucht. 7. 8. 9. Saamen. Pappel-Rosen. Herbst-Rosen.

Elizabeth Blackwell
(1707–1758)

Herbarium blackwellianum emendatum et auctum
Nuremberg, 1750–73
Shelfmark: Fag.GG.3.5-10

Elizabeth Blachrie was born in Aberdeen around 1707. She married her cousin, Alexander Blackwell, under clandestine circumstances and moved to London. There, Alexander worked briefly for a printing firm before setting up his own print shop. As he had neither served an apprenticeship nor joined a guild, he was heavily fined for breaking the trade rules and sent to a debtors' prison.

To pay off his debts Elizabeth, a skilled illustrator, decided to produce a new herbal – a description of plants and their medicinal uses – including unfamiliar plants as well as those found in Britain.

Elizabeth drew the images, made the copper engravings and coloured the printed pictures, then took them to Alexander for their Latin names and medical information. Supported by prominent physicians and horticulturalists Elizabeth produced *A Curious Herbal*, containing 500 plates. The first volume was published in London in 1737; the second in 1739. It was a great success, enabling her to secure Alexander's release. However, there was no happy ending for the couple: on 24 July 1747 Alexander Blackwell was executed in Sweden on a charge of treason.

Elizabeth's *Herbal* was translated into German by Christoph Jacob Trew, a doctor and botanist, who also added more information. The drawings were corrected according to the recent teachings of the Swedish botanist, zoologist and physician Carl Linnaeus; Nikolaus Friedrich Eisenberger re-engraved the plates; and this six-volume edition was published between 1750 and 1773. The Library acquired this beautiful set in 1802 as part of the Fagel Collection.

A manuscript from Aleppo
Syria, 7th century

Shelfmark: TCD MS 1511

LOCATED AT THE END OF THE SILK ROAD, and with easy access to Mediterranean ports, Aleppo thrived under the Ottoman Empire from the sixteenth to the eighteenth centuries. It achieved such fame that Shakespeare refers to it in his plays *Othello* and *Macbeth*. The city's international outlook led to the establishment of some of the oldest consulates in the world as well as the largest souks in the Middle East, where merchants could trade anything from spices to racehorses. Residents enjoyed freedom of conscience to practise their own religions, something denied to many Europeans at the time.

Merchants or chaplains of the Levant Company sourced Syrian manuscripts on behalf of private clients. This flow of Arabic manuscripts into Western collections helped to revolutionise European science and philosophy during this period.

This seventh-century manuscript of homilies draws on original texts of St Severus of Antioch, patriarch of Antioch and head of the Syriac Orthodox church between 512 and 538 CE. It came to the Library as part of the collection amassed by Archbishop James Ussher (1581–1656), who purchased many Syrian biblical manuscripts through fellow academics in Aleppo, and a Levant Company agent, Thomas Davies. The Syriac Orthodox church can claim some of the oldest surviving texts in Christianity and such manuscripts were of particular interest to Ussher for his research into the evolution of the church.

The text, which reads right to left, is written in Estrangelo, the earliest form of Syriac writing. This folio discusses the ascension of Christ into heaven.

The Marriage Certificate of James III and Maria Clementina Sobieska

1719

Shelfmark: TCD MS 7574

THIS LAVISHLY DECORATED MANUSCRIPT is the marriage certificate of James III (the Old Pretender, 1688–1796) and the 17-year-old Polish princess Maria Clementina Sobieska (1702–1735), the parents of Charles Edward Stuart (Bonnie Prince Charlie) and Henry, Cardinal Duke of York. It has a frontispiece bearing the Stuart and Sobieski coats of arms above a representation of a hilltop village that bears a strong resemblance to Montefiascone, near Lake Bolsena, north of Rome – their wedding venue and summer residence of Pope Clement XI.

That the union took place at all is nothing short of remarkable given that the events that led up to it played out like a soap opera: the bride was ambushed and imprisoned at Innsbruck to disrupt the match at the behest of King George I. The Irishman Charles Wogan, 'the Chevalier Wogan', and his band of officers facilitated the subsequent jail-break. A chase across Europe then ensued, involving faked illness, a maid in disguise, lost jewels, forged passports, broken axles and the spiking of some hapless pursuers' drinks. The escape party made it across the Alps to Montefiascone, where James and Clementina were finally married in a ceremony performed by order of the Pope on the night of 1 September 1719. The episode caused a scandal throughout Europe but unfortunately did not have a fairytale ending as the couple separated soon after their second son was born.

John Millington Synge's typewriter

Shelfmark: TCD MS OBJECT 79

THE WRITER JOHN MILLINGTON SYNGE (1871–1909) composed his great literary works on this tiny portable typewriter. Once removed from its sturdy wooden carrying case, the No. 5 Blickensderfer presents a lightweight, almost spectral mechanism. Synge's friend, the Celtic scholar and librarian Richard Irvine Best, not only advised Synge on his literary work but also encouraged him to use a typewriter, personally selecting this model for him. Best felt that it would be invaluable for Synge, who struggled with both spelling and grammar, in producing clean copy for publishers. When Synge brought his new typewriter home in 1900 he told his family that it spelt even worse than he did. He was to use this little machine for the rest of his life, typing every draft of his literary works on it, from the first to final version. His nephew, Edward Stephens, who lived next door to Synge throughout his youth, recalled hearing his uncle tapping away on his typewriter through the open window of the bedroom where he routinely worked.

The portable Blickensderfer was first introduced at the 1893 World's Columbian exposition in Chicago and cost $35. The revolutionary design allowed the typist to see their work at a time when most typewriters were understrike machines that concealed the writing. Each typewriter came with an extra typewheel, a dozen ink rolls and a tool kit. Another feature was the modified keyboard: the bottom row of keys contained the most commonly used letters, DHIATENSOR, to increase efficiency. The D key on this machine is now missing.

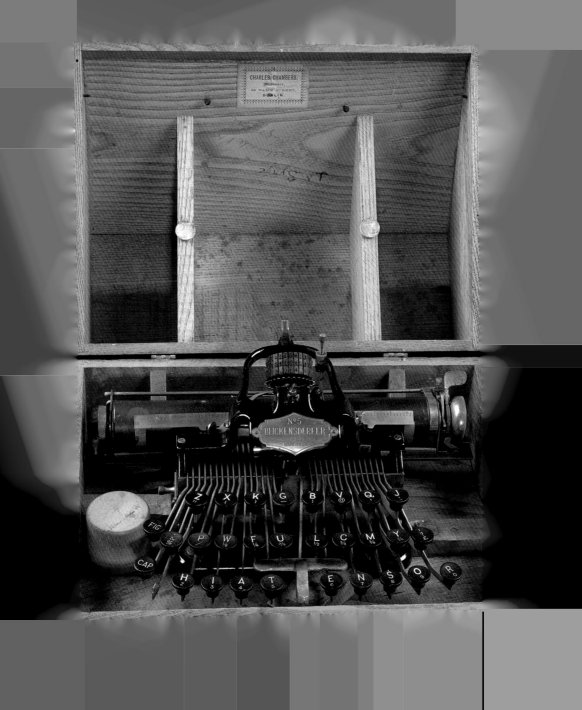

DOROTHEA HERBERT
(1767–1829)

Retrospections of an Outcast
1805–06

Shelfmark: TCD MS Deposit

RETROSPECTIONS OF AN OUTCAST IS THE DRAMATIC TITLE of a memoir written by Tipperary woman Dorothea Herbert, whose experience of mental illness formed the central drama in her life. Despite this, she was able to use her talent for writing, and painting, to produce plays and poetry as well as novels and this illustrated memoir. Herbert had a haphazard education and was lucky to get even the sketchy tutoring that she had; access to education was denied to many girls in the eighteenth century. We learn from her writings that she learned French, preferred poetry and art to needlework, and loved gardening and practical jokes.

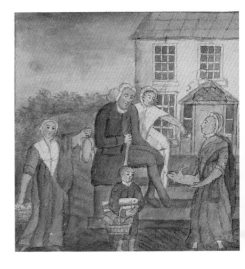

This memoir is a gold mine as women's records from this period are very rare. Not only does it provide details about what it was like to live in a rackety family home in the eighteenth century, but it also gives insight into unrecorded aspects of private life. For example, children are very often absent from historical records so Herbert's description of her childhood games is marvellous to read. The children were usually unsupervised and their games ranged from the educational (playing at being Robinson Crusoe) to the downright dangerous – the Herbert boys tried to set their music teacher alight.

Herbert also describes with much humour the efforts she and her friend Betty Hare made to beautify themselves (before Betty was whisked off in tears to be married at the age of fifteen). Their 'cosmetic endeavours' included going to bed covered in ointment and brown paper to improve their complexions.

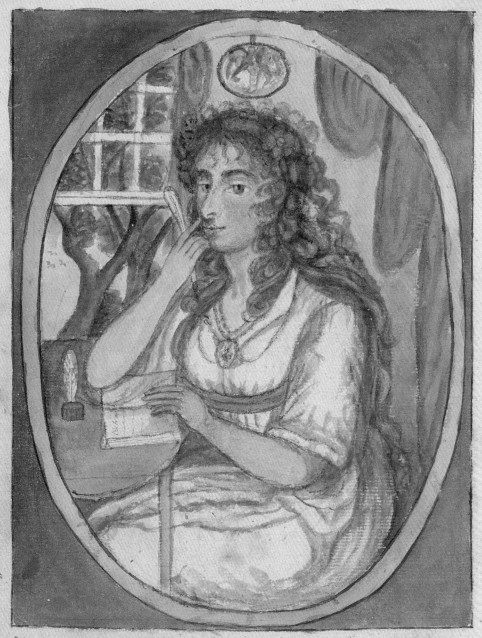

Dorothea Herbert Roe

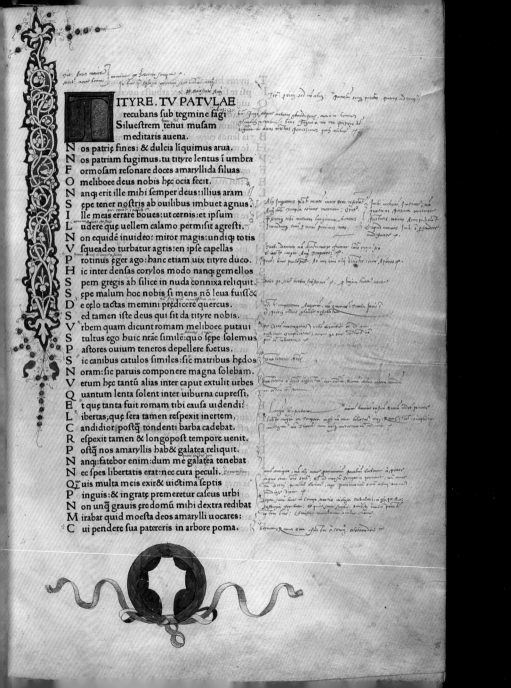

TITYRE. TV PATVLAE

TITYRE. TV PATVLAE
recubans sub tegmine fagi
Siluestrem tenui musam
meditaris auena.

N os patrię fines: & dulcia liquimus arua.
N os patriam fugimus. tu tityre lentus i umbra
F ormosam resonare doces amaryllida siluas.
O meliboee deus nobis hęc ocia fecit.
N amqꝫ erit ille mihi semper deus: illius aram
S ępe tener nostris ab ouilibus imbuet agnus.
L lle meas errare boues: ut cernis: et ipsum
L udere quę uellem calamo permisit agresti.
N on equidé inuideo: miror magis: undiqꝫ totis
V squeadeo turbatur agris: en ipse capellas
P rotinus ęger ago: hanc etiam uix tityre duco.
H ic inter densas corylos modo namqꝫ gemellos
S pem gregis ab silice in nuda connixa reliquit.
S ępe malum hoc nobis si mens nó leua fuisſ&
D e cęlo tactas memini prędicere quercus.
S ed tamen iste deus qui sit da tityre nobis.
V rbem quam dicunt romam meliboee putaui
S tultus ego huic nrāe simile: quo sępe solemus
S astores ouium teneros depellere foetus.
S ic canibus catulos similes: sic matribus hędos
N oram: sic paruis componere magna solebam.
V erum hęc tantú alias inter caput extulit urbes
Q uantum lenta solent inter uiburna cupreſſi.
E t quę tanta fuit romam tibi causa uidendi?
L ibertas: quę sera tamen respexit inertem,
C andidior postꝗ tondenti barba cadebat.
R espexit tamen & longopost tempore uenit.
P ostꝗ nos amaryllis hab& galatea reliquit.
N amqꝫ: fatebor enim: dum me galatea tenebat
N ec spes libertatis erat: nec cura peculi.
Q uis multa meis exir& uictima septis
P inguis: & ingratę premeretur caseus urbi
N on unꝗ grauis ęre domú mihi dextra redibat
M irabar quid moesta deos amarylli uocares:
C ui pendere sua patereris in arbore poma.

VIRGIL
(70–19 BCE)

Opera
Venice, 1470
Shelfmark: Quin 64

ON 16 FEBRUARY 1805 Henry George Quin, aged forty-five, shot
himself through his heart, leaving a note to say that he was tired
of living. In his will he left his small but remarkable collection
of books, along with the bookcase in which they were housed, to
Trinity College Dublin, from which he had graduated in 1781.

In 1785 Henry Quin had set off from Ireland on a Grand Tour
of Europe, spending time in Paris and other cities viewing and
purchasing fine editions of early printed books, mainly European
literature and the works of classical authors.

In 1790 books from the library of an Italian-Dutch bibliophile,
Pietro-Antonio Bolongaro-Crevenna, were auctioned in Amsterdam.
Quin bid successfully for several lots, despite having noted in his copy
of the catalogue that the lots on offer were 'the most unsophisticated
books I ever saw'. This edition of Virgil's *Opera*, printed on vellum by
Vindelinus de Spira, cost Quin 1,925 florins, the highest price paid for
any item in the auction; because of this, he was presented with the
auctioneer's gavel at the end of the sale.

This folio edition of Virgil's works is typical of an incunabulum
(a book printed before 1501) produced during the transition from
manuscripts to printed books. It does not have the title page that
was to become a convention in printed books and was illustrated
by hand after printing, mostly with illuminated initials. Quin com-
missioned its Morocco leather binding from the English bookbinder
Roger Payne.

WILLIAM MORRIS
(1834–1896)

The Works of Geoffrey Chaucer; now newly imprinted
London, 1896

MOST PEOPLE ARE FAMILIAR with William Morris' textile arts – furnishings with intricate designs often featuring birds and flowers. Perhaps fewer know that he was also a scholar and writer and, towards the end of his life, founded a printing company.

The Kelmscott Press was established in 1891 to fulfil Morris's wish to print beautiful books. During the seven years of its existence it published a total of 52 works in 66 volumes. By far the most ornate of these is the large single volume containing the works of Geoffrey Chaucer, now universally known as *The Kelmscott Chaucer.*

Morris had strong views on the effect he wanted to achieve, sourcing suitable paper and inks. He created his own fonts and specified the size of margins and spaces between words or lines. His old friend Edward Burne-Jones, with whom he had read Chaucer aloud when they were students at Oxford, provided 87 illustrations; the rest – decorative initials, frames and borders, small devices and the title page – are by Morris himself.

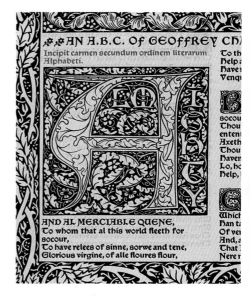

Printing of the 425 paper and 13 vellum copies took almost two years and was finished only six months before Morris died. The book was not cheap: paper copies cost £20 and vellum £120 (approximately £2,400 and £14,500 today), with pigskin binding costing an additional £13 (now £1,500), but the edition sold out. It is not very colourful – only red and black inks were used – but it is stunning.

But thus they mette, of aventure or grace;
And he saleweth hire with glad entente,
And asked of hire whiderward she wente.
And she answerde, half as she were mad,
Unto the gardyn, as myn housbonde bad,
My trouthe for to holde, allas! allas!

AURELIUS gan wondren on this cas,
And in his herte hadde greet com-
passioun
Of hire and of hire lamentacioun,
And of Arveragus, the worthy knyght,
That bad hire holden al that she had hight,
So looth hym was his wyf sholde breke hir
trouthe;
And in his herte he caughte of this greet
routhe,
Consideringe the beste on every syde,
That fro his lust yet were hym levere abyde,
Than doon so heigh a cherlyssh wrecched-
nesse
Agayns franchise and alle gentillesse;
For which in fewe wordes seyde he thus:

MADAME, seyeth to youre lord,
Arveragus,
That sith I se his grete gentillesse
To yow, and eek I se wel youre distresse,

That him were levere han shame, and that
were routhe,
Than ye to me sholde breke thus youre
trouthe,
I have wel levere evere to suffre wo,
Than I departe the love bitwix yow two.
I yow relesse, madame, into youre hond
Quyt every surement and every bond,
That ye han maad to me as heer biforn,
Sith thilke tyme which that ye were born.
My trouthe I plighte, I shal yow never repreve
Of no biheste, and heere I take my leve,
As of the treweste and the beste wyf
That evere yet I knew in al my lyf.
But every wyf be war of hire biheeste,
On Dorigene remembreth atte leeste.
Thus kan a squier doon a gentil dede,
As wel as kan a knyght, withouten drede.

SHE thonketh hym upon hir knees al
bare,
And hoom unto hir housbonde is she
fare,
And tolde hym al as ye han herd me sayd;
And be ye siker, he was so weel apayd
That it were impossible me to wryte.
What sholde I lenger of this cas endyte?

Simple directions in needle-work and cutting out; intended for the use of the national female schools of Ireland. To which are added specimens of work executed by the pupils of the Female National Model School
Dublin, 1861
Shelfmark: OLS POL S 120

Mary 'Paul' Pollard (1922–2005) was the first Keeper of Older Printed Books in Trinity, and a lifelong collector of children's books. The Library of Trinity College Dublin purchased her collection of 567 schoolbooks in 1985. Many of these were produced by the Commissioners of National Education, who administered primary schools in Ireland from 1831 until 1922.

This needlework textbook from 1861, intended for girls' schools, was compiled by Mrs Campbell, mistress of the Central Female Model School in Dublin. The introduction states that 'The practical knowledge of needle-work… must be regarded as very useful to all females, but particularly so to those of the humbler classes'.

The book begins with instructions for hemming and continues through basic stitches; button-holes; darning; knitting; more complicated stitches; lace work; and cutting out and sewing articles of babies' clothing. Worked examples, mounted on green paper, are bound in after the text. Although there are intricate small samples of stitches included, the most complicated item is this shirt. The directions for this are very general, rather than for a specific size. An italicised instruction advises '…then sew on the buttons *carefully*…'.

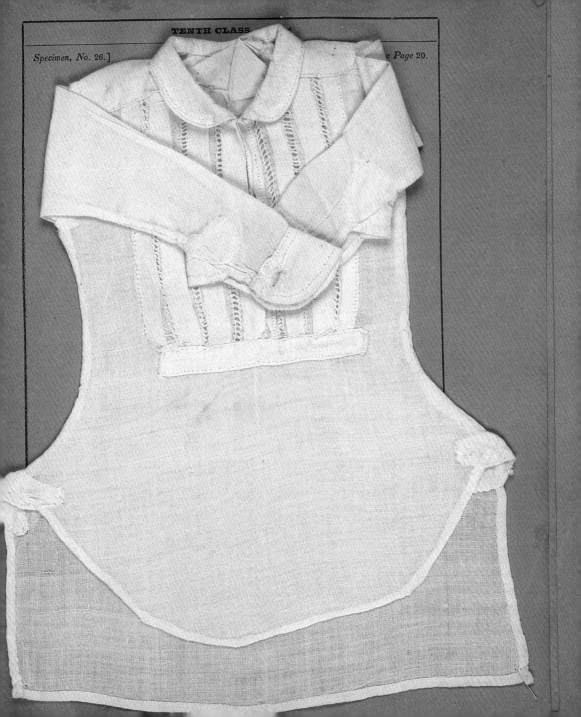

Brehon Law

Ireland, late 14th-early 15th centuries

Shelfmark: TCD MS 1316/2 page 25

THE BREHON LAW MANUSCRIPTS held in the Library of Trinity College Dublin give an insight into one of the oldest legal systems in Europe and how everyday life in early medieval Ireland was regulated. They detail the organisation of society, including the laws governing marriage, fostering, sick-maintenance, the use of pledges, bee-keeping, the control of dogs and the roles of church and state.

The honeybee (Old Irish *bec*) was very important in the early Irish economy, as demonstrated by the special law-text shown here, *Bechbretha* ('bee-judgments'), composed in the seventh century. There are many references to bees in other law-texts, in saints' *Lives*, in sagas and in poetry. As well as honey (Old Irish *mil*), each monastery required considerable quantities of beeswax (Old Irish *céir*) for candle-making, the waxed tablets used to practise scribal techniques, seals and adhesives. Much of the *Bechbretha* is concerned with the legal intricacies connected with the swarming of bees. In the law shown here, if a person finds a stray swarm they can claim it as their own property. A ninth portion of the honey must go to the head of the finder's clan or church.

At the bottom of the page shown here, the 21-year-old scribe Hugh McEgan records the date as Christmas Eve 1350, which was two years after the Black Death came to Ireland. He asks everybody who reads the page to say a prayer for his soul. However, the Annals of Ulster record McEgan's death nine years later at the age of 30.

D'Alton correspondence
19th century

Shelfmark: TCD MS 2327/64

THIS PACKAGE OF LETTERS between husband and wife John and Catherine D'Alton, spanning almost forty years of marriage from 1818 to the late 1850s, was presented to the Library in 1951. The archive was largely ignored for over 50 years for one good reason: the script was a maze of near-illegible words written horizontally and vertically on the same page. This was a money-saving strategy used in letter writing in the nineteenth century and it made transcription an eye-straining task. Faded ink did not help matters. Transcribing these letters was a complex palaeographical challenge, each word won with endeavour. John D'Alton spent significant periods away from the family home as he travelled on his circuit as an assize lawyer. His letters to his wife are the most impenetrable as he often scribbled on his knee while being jostled around the inside of a horse-drawn carriage. His wife Catherine writes in a much more accessible hand, keeping her husband in touch with family life and local gossip during his frequent absences. Perhaps the most satisfying outcome of this transcription came when two direct descendants from both sides, who had made previous failed attempts to transcribe the letters, were delighted to discover the transcribed text in the Manuscripts Department online catalogue.

Saothar 41: Journal of the Irish Labour History Society
2016

Shelfmark: PER 900 (2016), no 41

THIS SPECIAL 1916 COMMEMORATIVE ISSUE edited by Francis Devine, along with Sarah-Anne Buckley and Brian Hanley, contains wonderful colour prints of seven famous Irishwomen along with images of James Connolly and Irish Citizen Army volunteers parading outside the old Liberty Hall building in Dublin.

The back cover features a depiction of James Connolly by Jim Fitzpatrick (the artist behind the famous Che Guevara portrait) commissioned by the 'Reclaim the Spirit of Easter 1916' committee. The graphic images designed by Sonia Slevin enhance the publication. The principal essay, 'A Celebration of James Connolly & The Irish Citizens Army', was written by the President of Ireland, Michael D. Higgins. The essay 'An Introduction on Sources on the Irish Citizens Army', as well as Mary McAuliffe's essay on 'Women, Radical Politics & the 1916 Rising', investigate labour history of the period.

Notably, this distinctive volume of *Saothar* ('work' in English) received three launches in Dublin, Belfast and Glasgow throughout 2016.

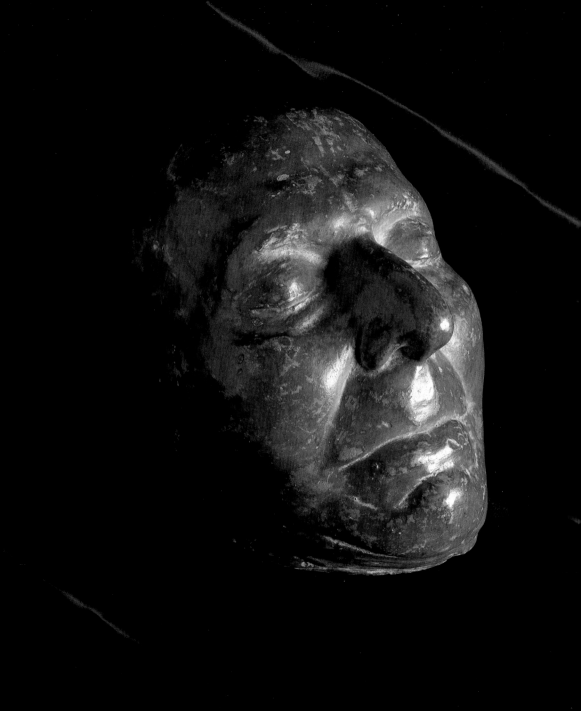

Death mask of Jonathan Swift (1667–1745)

Shelfmark: TCD MS OBJECT 58

THE GREAT PROSE SATIRIST JONATHAN SWIFT was born on 30 November 1667 in Dublin city. He entered Trinity College Dublin in 1682, aged 14, and graduated as BA in 1686. He became Dean of St Patrick's Cathedral, Dublin in 1713 and his satirical classic *Gulliver's Travels* (1726) is still widely read today.

Swift was declared of 'unsound mind and memory' in 1742; he died at 3pm on 19 October 1745, leaving the greater part of his estate to establish St Patrick's, Ireland's first hospital for the mentally ill. This death mask was made prior to autopsy by applying plaster to Swift's face to capture an exact likeness. It was probably taken within four hours of his death, during the period of *rigor mortis*, when the face still holds relatively firm. The eyebrows are sparse in contrast to the contemporary portraits of the Dean that depict him with strong, well-defined brows.

This mask, signed by the maker Del Veccho [?Del Vecchio], was originally in the possession of Oscar Wilde's father, the surgeon Sir William Wilde, author of *The Closing Years of Dean Swift's Life* (1849). The colour of the mask is the result of the application of a flesh-coloured paint that has since darkened. A marble bust of Swift by Louis François Roubiliac, commissioned by Trinity College students shortly after his death, is on display in the Long Room. Dean Swift was buried in his own cathedral, St Patrick's, close by his dear friend Esther ('Stella') Johnson, in accordance with his wishes.

The Book of Kells

*c.*800

Shelfmark: TCD MS 58 folio 8r

THE BOOK OF KELLS, THE NINTH-CENTURY gospel book treasured in the Library of Trinity College Dublin, does not always readily yield up its secrets. This summary of the gospel announcing the birth of Christ is an exuberant combination of colour, sinuous letter-forms, human figures, peacocks and snakes. The bands of display script composed of contorted animal letterforms defy legibility. A later reader transcribed the display script at the foot of the page: NATIUITAS / CHRISTI IN BETHLEM IU/DEAE MAGI / MUNERA OFFERUNT ET / INFANTES INTER/FICIUNTUR REGRESSIO ('The birth of Christ in Bethlehem of Judea. The wise men offer gifts and the children are killed...).

The small, seemingly stray detail in the lower left margin of the page, standing alone like a medieval afterthought outside of the framed proclamation of the birth of Christ, went unnoticed in scholarly analysis of this page. Then along came technology: the digitisation of the Book of Kells in 2013 changed the way that it could be studied. Where once one could barely discern the base and stem of a blurred object, now the arms and red outline of a processional cross topped with a bird, probably an eagle, came into focus when magnified at high resolution. The red flared tail at the base suggests that this was a cross that could be carried in procession or slotted into a base to stand on the altar. This minor detail, long overlooked, may represent a cross that once stood in the monastery where the Book of Kells was created.

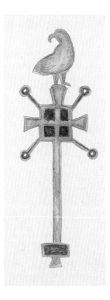

BELOW RIGHT: Detail of processional cross in the lower left margin of folio 8r, opposite

BELOW LEFT: Artist's impression of the original processional cross, drawn by Jane Maxwell

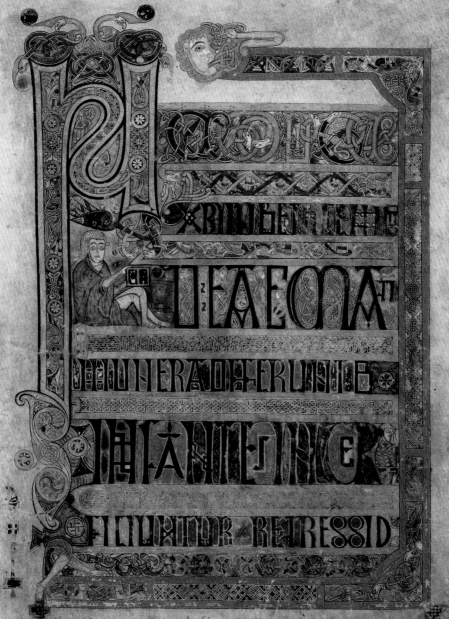

Natiuitas xpi in bethlem iudeae ... magi manera offerunt
et infantes intessicunfur

Camp III . 7.6.24 . 21000 ft

A quiet day at Camp III. Norton's eyes are much improved & he will be able to go to the base tomorrow if he wishes. There is no news of the MI attempt. I have very little faith in its success, since neither of the two seem to be fit enough to make it. This will be the last of the attempts. Already arrangements are being taken in hand for the evacuation of the camps. Within a week we should be all off the mountain. And none will regret it since all have had a hard quelling this year & need a rest at lower elevations.

Camp III . 8.6.24 . 21000 ft

Eyes again glued to the mountain. There is just a chance of Mallory and Irvine getting to the summit. But the clouds today have been very thick. Only on occasions and for momentary intervals do we happen to see the final pyramid through the mist. We have therefore seen nothing of the climb and can only hope for the best. There is no sign of either having returned as yet to Camp IV. Whatever happens, this must be the last attempt and in a few days we shall be leaving these high camps.

Camp III . 9.6.24 . 21000 ft

A most anxious day. Not a sign of Mallory or Irvine. At the latest they should have been at Camp IV this morning, but there is no trace of them as yet. The condition of the mountain also has changed for the worse. For the most part the day it has been in cloud with every sign of a bitter wind. Everything points to a catastrophe, which would be a disastrous ending to the affair. Norton is also of the same opinion. He has sent instructions to Odell on the North Col to do what is possible in the way of a search. But he is very loth to involve more people in the mountain especially as there is indication of the approach of the monsoon. Indeed everyone should be off the mountain now. We saw Odell and two coolies climbing up towards Camp V so that a the search party has been organised before Norton's instructions arrived. These are came up from Camp II into a batch of coolies. His intention was to evacuate this camp according to plan. But, of course, we must wait now until we learn what has happened or find that no more information is to be obtained. The sooner all are off the North Col, the better it will be.

Camp III - 10.6.24 - 21000 ft

There can be no doubt; the worst has happened. Not a sign of Mallory & Irvine. They must have slipped near the summit of the mountain and fallen down the cliff. It is a horrible catastrophe and is certain to cause

MAJOR R. W. G. HINGSTON
(1887–1966)

Mount Everest expedition diary
1924
Shelfmark: TCD MS 10473 folio 36 (diary entry for 10 June); TCD MS 10484/4/1, 2 (photographs)

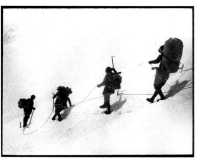

DID GEORGE MALLORY AND ANDREW Irvine reach the summit of Everest before they died? They were last sighted around 245 metres from the 8,848-metre summit before clouds rolled in and hid them from view. Unfortunately the evocative diary of Major Richard William George Hingston that chronicled the expedition cannot answer that question.

Hingston was the medical officer and naturalist on the 1924 British Everest expedition. He kept a meticulous diary in which he recorded, among a myriad of details, the hope for Mallory and Irvine's success on the group's last summit attempt. Over a few days' worth of entries, that hope turned to concern and finally to despair in the heart-wrenching entry of 10 June 1924 when Hingston wrote: 'There can be no doubt, the worst has happened. Not a sign of Mallory and Irvine. They must have slipped near the summit and fallen down the face of the mountain'.

Hingston's pencilled accounts of this emotional experience are profoundly moving. Despite the discomfort, fatigue and cold at high altitude and the limitations of their equipment, this diary survives as an enduring testament to a valiant team of mountaineers.

In memory of our friend and colleague, Professor Séamus ('Shay') Lawless, who lost his life on the descent from Mount Everest, 16 May 2019

Robert Macfarlane (1976–) and Jackie Morris (1961–)

The lost words: a spell book

2017

Shelfmark: LB Folio Case: 5897

The nature and landscape writer, Robert Macfarlane, was inspired to write his 2017 book *The lost words: a spell book* when he realised how many words describing the natural world had been dropped from the latest edition of the *Oxford Junior Dictionary*. It seemed that modern, urban-dwelling, technology-centred children no longer used these words, but without them Macfarlane feared the world they represent would be forgotten. He created a magical work of poem-spells to conjure this world back into being. He picked twenty plant, bird and animal names and travelled the route of the alphabet, from acorn to wren. He wove his poems around their characters and their letters. These were printed on artist Jackie Morris' wonderful two-page spreads; illustrations capturing first the scattered letters, then a close-up and finally the living thing as a part of its habitat: heron 'rock still at weir sill', Kingfisher 'zingfisher, singfisher'. The book had been planned as a work for children and primary schools across Britain have been provided with copies. However, the book's beauty, wit and wisdom have inspired people of all ages, more conscious now than ever of the perilous state of our natural world. Carers working with vulnerable people use this book and it has been adapted for many artistic expressions: dance, theatre, even graffiti. Now, several successful musicians are recreating the poems as songs – conjuring up the magic of this beautiful book in another art form.

HARRY CLARKE
(1889–1931)

Stained Glass Studios archive

Shelfmarks: TCD MS 11182/1062, 1125

HARRY CLARKE'S IS ONE OF A MERE HANDFUL of names that is instantly recognisable in Ireland. His stunning designs for stained glass windows grace churches great and small in every county on the island. Less well known is the fact that he began his career in the church-decoration business founded by his father, Joshua, in 1886. Young Harry left school in his mid-teens, after the early death of his mother, and went to work in his father's design studio while taking night classes at the Dublin Metropolitan School of Art. When Joshua Clarke died in 1921 Harry and his brother Walter kept the business going, with Harry taking over management of the Stained Glass Studios and Walter responsible for the decorating business. Harry, who had never enjoyed good health, died at the age of 40 in 1931.

The earliest section of the Clarke Stained Glass Studios archives in Trinity (MSS 5970–6167) is the business administration records, including order books, employee records and the financial accounts of a business whose designs were commissioned in Great Britain, the USA, Canada, Africa, Australia, New Zealand and Asia. The later section (TCD MS 11182) contains architects' plans, photographs and reference materials. This section also contains more than 2,000 stained glass designs in the form of rough colour sketches, pencil drawings and photographs, mostly for religious institutions. Although the bulk of the material covers the period after Harry Clarke's death in 1931 he remained a guiding inspiration for generations of artists and designers.

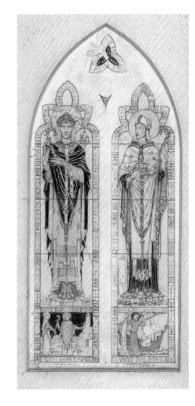

ABOVE: Pencil drawing for two-light window featuring St Macartan and St Tigernach

OPPOSITE: Colour design for a window depicting St Ursula

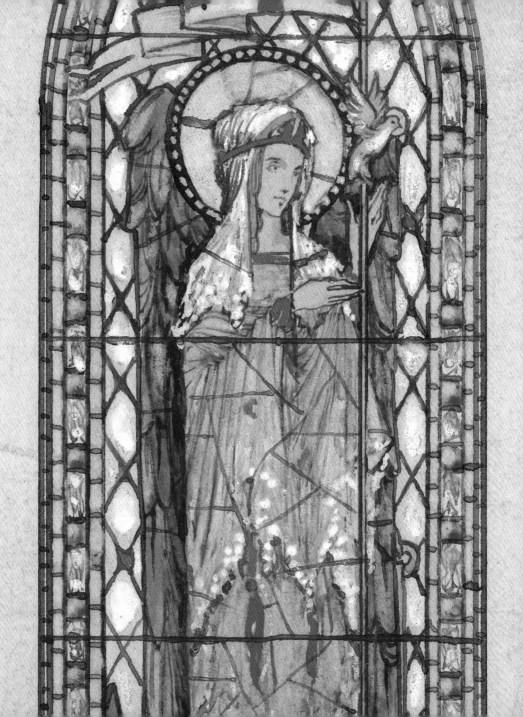

where my parents lived when they were young and where, presumably, they instituted me. Orme is a painter's name, isn't it? A painterly name. It used to go well, down at the right-hand corner of a canvas, discreetly small yet unmissable, the O and brush eye, the r faintly art-nouveau, the m like shoulders shaking in mirth, the e like — oh, I don't know what. 'o' | do — the handle of a chamber pot. So there you have, Orme [Eden Maler, the master mauler. Who now can paint no more.] the master painter, who paints no more.

What I want to say is

[Dirty rotten scheming bastards, every one of them.]
[Storm today. Amazing [gusts of] winds, battering on the]
house. Battering? Wrong

Storm today. Amazing winds [battering the house] smacking against the house, [the weather in a rage] shivering its timbers. What I want to say is this, that I have decided to weather the storm. The interior one. [Why do storms always remind me of childhood?], make me feel that I'm back there, crop-haired, in short trousers and drooping socks. Childhood is supposed to be a springtime but for me it was always autumn. [seems to have been always autumn, the trees settling in ?], Wood and the rocks [flying up like flakes] [wheeling and] gyring like flakes of straw from a fire]
Derops

JOHN BANVILLE
(1945–)

Notebook containing drafts for *The Blue Guitar*

2012–14

Shelfmark: TCD MS 11517

JOHN BANVILLE IS ONE OF IRELAND'S GREAT contemporary authors. The Library of Trinity College Dublin is fortunate to have acquired three tranches of his literary archive.

Many of Banville's manuscript drafts are in beautiful bound notebooks, suggesting an aesthetic consideration in advance of the act of writing. In this notebook, Banville develops the ideas that will result in the novel *The Blue Guitar*, published in September 2015. The Banville archive also includes, for example, 21 typescript and annotated drafts of his 2005 Booker Prize-winning novel *The Sea*, permitting the reader insights into the artistic process of an exceptional writer.

Within his notebooks, there is detailed evidence of Banville's working methods: words and phrases are considered, abandoned or reworked. His italic handwriting is elegantly formed, rendering each page a thing of beauty. For example, in this section of the novel where the protagonist, Oliver Orme, seeks to express a challenging thought, Banville reworks sections of text to distil the atmosphere of the passage:

'What I want to say is
[Dirty rotten scheming bastards, every one of them.]
Storm today. Amazing [gusts of winds, battering on the house. Battering? Wrong]
Storm today. Amazing winds [battering the house] smacking against the house, [the weather in a rage.] Shivering its timbers.'

SAMUEL BECKETT
(1906–1989)

Postcard to Josette Hayden
1982
Shelfmark: TCD MS 11488/334
© Estate of Samuel Beckett

PERHAPS THE GREAT MYSTERY OF SAMUEL BECKETT'S ART is how he is
able to evoke so much with so little. 'A country road. A tree. Evening.'
So begins *Waiting for Godot* (1953). As his art developed, the image
and the words contracted, and yet somehow evoked more and more.
By *Not I* (1972), his stage setting had shrunk to 'a moving mouth
with the rest of the stage in darkness'. Not for nothing did he entitle
a 1969 short story 'Lessness'. In the collection of Beckett's letters in
the Library of Trinity College Dublin, there is a series of postcards
in which the writer communicates with those closest to him through
the same paradoxical language of impoverished richness, simple
words and simple images producing an effect far from simple. This
was particularly true of the postcards he sent to the painter Henri
Hayden and his wife Josette. Typically the postcard images have an
almost studied banality, but seem to speak via a visual language.
So on 23 August 1982, when Beckett writes to Josette Hayden, he
sends her an alpine landscape just picturesque enough to be worth
photographing, but without intimating any sublime revelation. It
is as if the image is stumbling towards significance. Inside, Beckett
has written only a few words separated by an ellipsis, investing the
thin air of the image with a strange yearning: '*que lentement... / je
t'embrasse*' ('how slowly... / love, Sam'). A simple image, simple
words: and yet the effect is to evoke emptiness, distance, and desire.

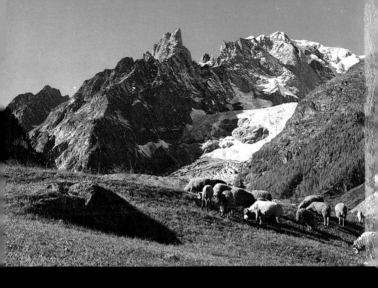

Via aerea

334

COURMAYEUR m.1224
Aig.Noire m.3773 - M.Bianco m.4810
Ghiacciaio la Brenva
La Chiesa N.D.Guérison m.1444

23.9.92

que lentement ...
je t'embrasse.
Sam

ZANELLA ANGELO - COURMAYEUR

Madame Hayden

Reuil en Brie

77 La Ferté sous Jouarre

FRANCIA

CASTELLO DI
MIRAMARE - TRIESTE
150
ITALIA T.MELE

CASTELLO DI
MIRAMARE - TRIESTE
150
ITALIA T.MELE

SIMON VAN DER STEL
(1639–1712)

Simon van der Stel's Journal of his Expedition to Namaqualand
1685
Shelfmark: TCD MS 984

IN 1602 THE DUTCH EAST INDIA COMPANY was formed. It established (and defended) a monopoly in trade, particularly in spices – cinnamon, cloves, pepper and nutmeg. The Company was extremely successful, extending its network from Africa, Arabia, and the Persian Gulf to China and Japan. The Dutch settled the Cape of Good Hope, conveniently positioned on the trade route from Holland. Simon van der Stel was the Governor of the Cape from 1679 to 1699, and in 1685 he commanded an expedition to Namaqualand where it was hoped copper would be found. His official report, accompanied by 72 coloured illustrations, was subsequently sent to the East India Company headquarters. Under circumstances which remain unclear a section of the report was removed from the Company's archives in the early 1690s.

The Library of Trinity College Dublin acquired this 'Dagh Register', or journal, in 1802 as part of the library of Baron Hendrik Fagel. Its significance was not fully appreciated until 1932 when Gilbert Waterhouse, professor of German at Trinity College, published his edition of the journal.

The 72 drawings accompanying van der Stel's report are thought to have been executed by Hendrik Claudius, a Silesian apothecary employed by the Company to document natural history. The first image in the journal is a general view of the Copper Mountains, with van der Stel's camp in the centre. There is also one illustration of two Namaqua individuals. The remaining drawings depict animals, birds, reptiles, plants, insects and fish.

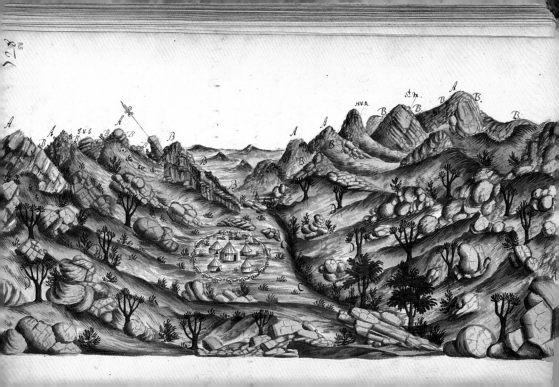

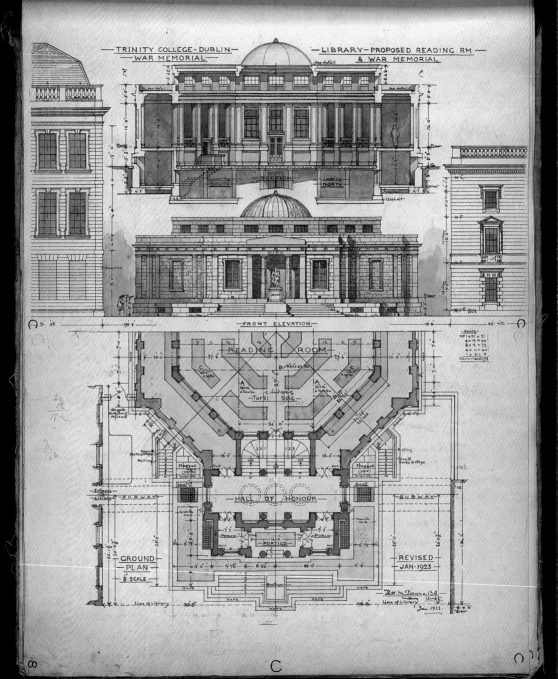

—TRINITY COLLEGE·DUBLIN—
—WAR MEMORIAL—

LIBRARY·PROPOSED READING RM
& WAR MEMORIAL

Looking SOUTH — SECTION — Looking NORTH

—FRONT ELEVATION—

READING ROOM

HALL OF HONOUR

SUBWAY SUBWAY

PORCH PORCH

PORTICO

GROUND
PLAN
⅛ SCALE

REVISED
JAN·1923

Thos. M. Deane, B.A.
Archt
Jan. 1923

Architectural drawings for the Reading Room and War Memorial, proposed for the Library of Trinity College Dublin
1923
Shelfmark: TCD MUN/MC/42

THIS IS ONE OF A SERIES OF architectural plans by Sir Thomas Manly Deane (1851–1933) for the 1937 Reading Room, the library building standing between the Old Library and the Examination Hall in Trinity College. In 1919 the College invited design submissions for a war memorial dedicated to the staff and students who died in the First World War. Deane's designs placed a Hall of Honour at the entrance to an octagonal building that would accommodate a new Library reading room. The Hall of Honour, which opened in 1928, housed the Roll of Honour commemorating the 471 Trinity students, staff and alumni who lost their lives in the war. It was not until almost a decade later, with the construction of the Reading Room, that the hybrid building was complete. The Reading Room, surrounded by a raised gallery, contained 160 seats. A perimeter room below the gallery was reserved for academic staff and women readers. On 2 July 1937, twenty years after he had fought with the Irish Volunteers in the Easter Rising of 1916 (against which Trinity College had vigorously defended itself), Eamon de Valera, president of the Executive Council of the Irish Free State, was invited to open this new Library Reading Room. The irony cannot have been lost on either party. Deane's beautifully detailed designs are held in the Library's College Archives collection, along with hundreds of other plans (executed and otherwise) for College buildings.

MICHAEL DAVITT
(1846–1906)

Davitt Papers (TCD MSS 9320-9681)
Shelfmark: TCD MS 9567 folio 50 (diary, 1896);
TCD MS 9477/4425 (telegram, 1895)

THE GIRL IN THE PHOTOGRAPH is Kathleen Davitt (1888–1895). She stares intently at the camera, wearing a formal dress and a wide-brimmed hat. This albumen print, measuring only 40 x 50 mm, is overexposed, making the child appear almost ethereal. The fragile photograph, cracked and roughly cut at the edges, is stuck to the pastedown of a small leather pocket diary. It is part of a collection of correspondence, writings, journals and photographs belonging to Michael Davitt (1846–1906), founder of the Land League, labour leader and international humanitarian. Davitt used his journals and camera to record his experiences when travelling in Africa, America, Australia and Europe.

Davitt's life was defined and shaped by profound challenges: his family's eviction when he was aged four and their subsequent emigration to England, the loss of his arm at the age of eleven and periods of imprisonment in his adult life. These events helped motivate Davitt's campaigning activities in land reform and workers' and prisoners' rights. However, this photograph has a much more personal significance for Davitt. While travelling to Australia for a lecture tour in 1895 he received the devastating news that his daughter, Kathleen, had died suddenly of tuberculosis. His wife encouraged him to proceed with the tour, and he did not return home for another seven months.

In this single image one can therefore read the whole tragedy of a father grief-stricken at the loss of his young daughter. Throughout 1896 Davitt carried her likeness close to his person, within this poignant little diary.

Michael Davitt
67, Park Road.
Battersea. London

"Weep not for me,
Be blithe as wont, nor tinge with gloom
The stream of love that circles home ;
I still am near,
Watching the smiles I prized on earth."

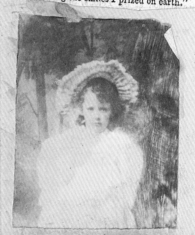

"Yet well I know the voice of Duty,
And, therefore, life and health must
crave,
Though she who gave the world its beauty
Is in her grave.

£1.50 lot
Released 28t July, 1987
by bonos;

50

18

Nos

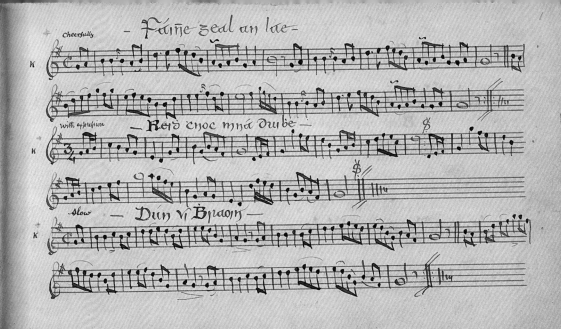

James Goodman collection of Irish music

Shelfmark: TCD MSS 3194 and 11320

IRISH TRADITIONAL MUSIC HAS come down to us mainly through oral transmission, passed from one generation of musicians to the next. This has contributed to its continuing vibrancy but also left it vulnerable to disruption and loss – particularly in the period of the Great Famine and the consequent sharp decline in population through mortality and mass emigration.

In these circumstances we must be especially thankful for the work of Canon James Goodman (1828–1896), professor of Irish at Trinity College Dublin. In his youth Goodman, a native Irish speaker and uilleann piper, collected tunes directly from local musicians performing in Cork and Kerry. In the 1860s he transcribed them into a set of four notebooks which came to Trinity College Library after his death. Two volumes containing the words for some of the tunes, long thought lost, were rediscovered by Goodman's descendants a century later and reunited with the collection.

Present-day traditional musicians are fascinated by this seminal collection and so the Library has collaborated with the Irish Traditional Music Archive (ITMA) on several projects to make it more easily accessible to a worldwide audience. Many of the tunes were published by ITMA in the two-volume *Tunes of the Munster Pipers* (1998; 2013) and as interactive online scores. Goodman's notebooks have been digitised and uploaded to the Library's digital collections and are also available through a dedicated website (goodman.itma.ie). By facilitating performances and recordings, these resources ensure that Goodman's efforts to 'preserve the music of my native province' are actively fulfilled.

'Silence is Requested'
A theatrical celebration of the Berkeley Library at 50

IN 2017, AS PART OF THE FIFTIETH ANNIVERSARY celebrations of the brutalist gem that is the Berkeley Library, eight final-year students of the Trinity College Dublin Lir Academy of Dramatic Art researched, created and performed a site-responsive, immersive theatre experience entitled 'Silence is Requested'.

The entire Berkeley Library became a stage, with an audience comprising Trinity staff and students bearing witness to a celebration of the 1960s with all its groovy twists and turns. This was a play exploring many aspects of the building's history, context and purpose, its creators weaving a story of love, loss and betrayal.

As a promenade piece, vignettes were staged throughout the building with each performance demanding direction from its audience. The students interviewed Library staff to uncover real-life events; one strand followed a student trying to avoid her diplomat father so that she could elope to marry the Deputy Librarian!

Multiple performances took place over three warm summer days. Existing only in the memories of those who witnessed it, the ephemerality of the 'Silence is Requested' piece renders it at once a joyous if fugitive experience. This play was part of the students' final assessments. As Trinity continues to reimagine the undergraduate curriculum, it increasingly takes up the opportunity to showcase students' research. Performances like these throw down the gauntlet to librarians and archivists to respond to the challenge of preserving such commemorative events for future generations.

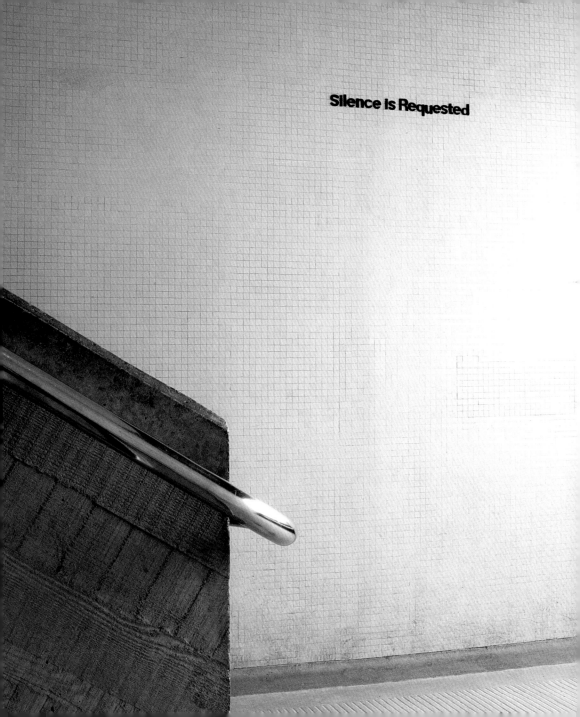

The Book of Leinster
Ireland, 12th century
Shelfmark: TCD MS 1339, p. 159

THE BOOK OF LEINSTER (*Leabhar Laighean*) has a claim to be the most important of the twelfth-century manuscripts held in the Library of Trinity College Dublin. The 'prime historian of Leinster' Áed Úa Crimthainn, abbot of Terryglass, County Tipperary, wrote the text during a period of huge ecclesiastical reform and political turmoil in Ireland. The Book of Leinster is an anthology of early Irish sagas, genealogy, medical knowledge, place-name lore and the study of grammar.

Most famously, it contains the Irish 'Book of Genesis' (*Lebor Gabála Érenn*), which establishes the place of Ireland, the Irish people and their language in a biblical world setting. The Irish language, according to this book, was created after the confusion at the Tower of Babel. It claims that Irish avoided all the 'shortcomings' and 'confusion' found in the other languages and was thus deserving of special recognition. This origin legend was particularly relevant in medieval times when Irish was threatened by the enormous prestige of Latin.

A very important version of the famous Irish saga *Táin Bó Cúailnge* (Cattle Raid of Cooley) and the story of the warrior Cú Chulainn is also included in the Book of Leinster. This page is from the Dindshenchas (place-name lore), opening with the words: *Temuir, unde nominatur* (Tara, whence is it named?).

Lucy heard noises.
The **noises** were coming from
inside the **walls.**

They were
hustling noises
and bustling noises.

They were
crinkling noises
and crackling noises.

They were
sneaking,
creeping,
crumpling
noises.

NEIL GAIMAN (1960–) AND DAVE MCKEAN (1963–)

The Wolves in the Walls
2003

Shelfmark: HX-64-870

THE BEST-KNOWN COLLECTION OF CHILDREN'S BOOKS in the Library of Trinity College Dublin is undoubtedly the Pollard collection of more than 10,000 volumes dating from the seventeenth to the early twentieth century. However, the story does not end there. The Library of Trinity College Dublin benefits from the legal deposit legislation of both Ireland and the United Kingdom, meaning that it must receive a copy of every book published in Ireland and may claim copies of works published in the United Kingdom, and so our readers can access some of the finest current children's literature. One such modern classic is *The Wolves in the Walls*, written by Neil Gaiman and illustrated by Dave McKean. This impeccable collaboration of writing and art is notable because its readership includes both children and adults, even though its themes may seem somewhat chilling for younger readers. But children do sometimes like to be scared and the layers of meaning in this story make it a useful tool for discussing many of the issues that a child might face. It is also a reminder to adults to try to understand a child's perceptions and remember our own childish selves. The world of the imagination, the power of belief, the pain of being misunderstood, the facing of fear and the courage to act are all explored. The story is dark, the wolves are scary, but they are ultimately vanquished and shown to be just as fragile as the people. McKean's illustrations are a dark and stirring blend of photography, computer imagery and drawing, and create a claustrophobic and compelling atmosphere. The book has also inspired a musical and a virtual reality film.

Records of the Roman Inquisitions
1626

Shelfmark: TCD MS 1245 folio 36r

THIS DOCUMENT, FROM THE RECORDS of the Holy Office, dates from 1626. It bears the signature and seal of the Franciscan historian Luke Wadding (1588–1657) and contains a statement by him regarding a Belgian man accused of heresy. Several documents of Irish interest exist within these records, including those referring to Irish men and women accused of various transgressions against Church regulations, as well as Irish clergy involved in the bureaucracy of the investigations.

Collectively these documents are sometimes referred to as the 'Records of the Roman Inquisitions' (which spanned the sixteenth to the eighteenth centuries), and are among the largest collections of this type in any international repository. The subjects covered include the sentences of trials relating to heresy, sorcery and bigamy, and reports – sent to Rome – on litigation before provincial tribunals.

This material forms part of a larger collection of Church-related documents taken from the Vatican to Paris in 1813 by Napoleon, who dreamed of a central archive for the empire in the French capital. The Trinity College Dublin collection includes papal bulls and letters from the time of Boniface IX (1389) to Pius VI (1787). The documents found their way, via a circuitous route, to the Library of Trinity College Dublin in 1854. The iron-gall ink used in these documents has had a corrosive effect on the paper over the centuries. The fact that so many other Vatican records from this period were lost or destroyed makes the Trinity College collection even more historically valuable.

...dingus ord. Min. regul. obser. sacræ Theologiæ Professor
...una qualificator fidem facio et attestor me ex commissio-
...ippoliti Mariæ Commissarij sancti officij plene instruxisse re-
...ibus diebus circa præcipuos et necessarios articulos nostræ
...e, et circa doctrinam Christianam iuxta eius imbecillem
...latoram Simonem Ardi Belgam; eumq̃ sæpius coram
...ter credere, et tenere quicquid credit et tenet s. R. ecc.ᵃ
...respuit, nec ullum iam sibi superesse dubium in ijs
...itabat ex crassa ignorantia, ut affirmat, et non ex malitia.
...præsens testimonium, ne amplius similem liceat ostendere
...a manu scriptum, et proprio sigillo munitum in æde s. Pi-
... Kalen. Maias 1616.

Fr Lucas Waddingus qui supra

bringing his lunch to him, when Fray trod nearby. That had saved them. The people of Tregon Marus had not been so lucky.

"There was a crash, and then everything just shook," said Camus, shivering as he told it. "I don't think there was a yard of wall left standing. The houses just fell in on themselves, and—even from where I was, we could hear the people. Then I heard the wolf things, and we ran." He took the piece of meat that Snibril gave him and they ate it hungrily.

"Did no one else escape?" he asked.

"Escape? From that? Maybe, those outside the walls. There was Barlen Corronson, the cutter, with us until yesterday. But he went after the syrup of those humming things, and they got *him*," he grumbled. "What's that? No, thanks, I'll not go north! Me and the wife will go east, see what we can find."

Terry Pratchett (1948–2015)
The Carpet People
1972
Shelfmark: J 9928

When Terry Pratchett published his first novel in November 1971, he was a little-known journalist, aged just 23. His publisher, Colin Smythe, Ltd, was a small and relatively new business. Despite a print run of only 3,000 copies, *The Carpet People* was picked up by the UK legal deposit system, whereby the Library of Trinity College Dublin may claim copies of any books published in the UK.

Trinity's copy arrived soon after publication: the accessions stamp is dated 17 January 1972. The leaf for pages 33 and 34 is tipped in, as with all copies of this first edition, because the printer had accidentally printed the illustration on page 34 upside down. One of more than 30,000 legal deposit books acquired that year, it received a 'J' shelfmark for 'juvenile' materials.

Terry Pratchett became Britain's most successful writer during the 1990s, published in more than 40 countries and translated into more than 35 languages. Trinity awarded him an honorary degree in 2008 and appointed him an adjunct Professor of English. Colin Smythe, long Pratchett's literary agent and himself a Trinity alumnus, donated all non-UK publications of Pratchett's work: every single translation and edition now forms part of a much-treasured special collection.

Academically Pratchett's work has been under-researched, but now, inspired by the Library's rich holdings, a group of Trinity researchers is investigating Pratchett through the lenses of children's literature, literary translation and digital humanities. The humble copy of that first novel at J 9928, however, serves as a beautiful reminder of the gems buried among the millions of legal deposit books.

Arnaldo Pomodoro
(1926–)

Sfera con Sfera
1982/83

Standing proudly on the podium of the iconic brutalist Berkeley Library is *Sfera con Sfera* ('Sphere within Sphere'). Properly part of Trinity College Dublin's Art Collections rather than a Library treasure, this sculpture by renowned Italian artist Arnaldo Pomodoro is, however, intrinsically linked to the Library. The 'Pomodoro sphere', as it is known locally, acts as a meeting point, photo backdrop and point of interest for thousands of students, staff and tourists as they move through Trinity's beautiful campus.

The sphere exemplifies the long association the Library has enjoyed with the College Art Collections. Before the opening of the purpose-built Douglas Hyde Gallery in 1978, the space underneath the podium where the sphere now stands served for a decade as an art gallery. Today both the historic and contemporary library buildings feature paintings and sculptures drawn from the Art Collections' eclectic catalogue. Installed in the mid-1980s, the sculpture looks custom-designed for the space it inhabits; it perfectly complements the concrete angles and glass curves of its backdrop, the Berkeley Library.

Variants can be seen across the globe – for instance, at the United Nations plaza in New York and the Cortile del Belvedere at the Vatican Museums in Rome. Pleasingly, there is also an example on the campus of the University of California, Berkeley – the town named after the same eighteenth-century Trinity philosopher in whose honour the Berkeley Library was christened.

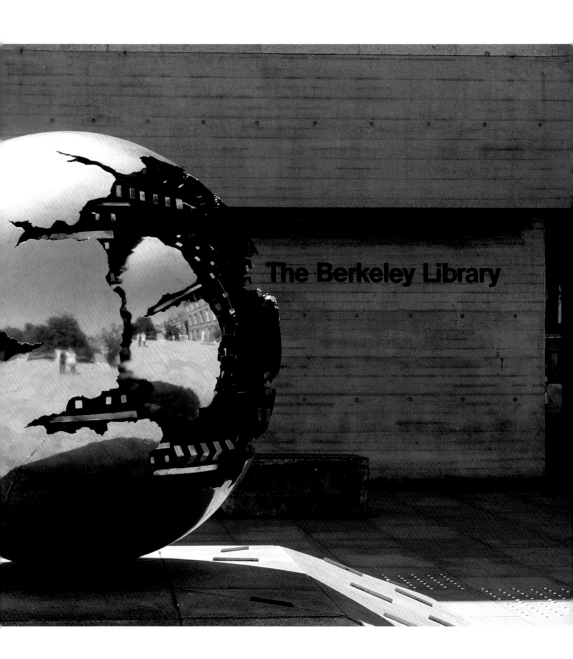

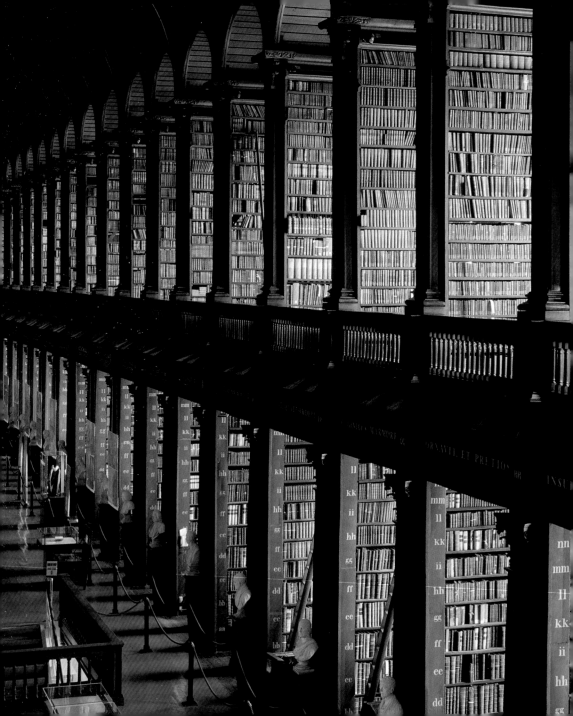

ACKNOWLEDGMENTS

I would very much like to acknowledge the expertise, enthusiasm and extensive knowledge and skills of my colleagues in the Library and across the University.

We could have filled several volumes with Library treasures, and we are planning an associated online exhibition to which we will add more riches from the Library.

I am indebted to the input and assistance of: Michelle Agar, Susie Bioletti, Elizabethanne Boran, Siobhán Dunne, Lydia Ferguson, John Gillis, Estelle Gittins, Arlene Healy, Aisling Lockhart, Helen McGinley, Jack McGinley, Jane Maxwell, Deirdre McNulty, Shane Mawe, Andrew Megaw, Chris Morash, Michael Nasom, Caoimhe Ní Ghormáin, Clíona Ní Shúilleabháin, Dererca Nolan, Paula Norris, Ellen O' Flaherty, Christoph Schmidt-Supprian, Laura Shanahan, Greg Sheaf, Roy Stanley and Jillian Wilson.

Gill Whelan deserves particular appreciation for her skilful creation of the stunning digital images.

Finally, I am especially grateful to Felicity O'Mahony for all her thoughtful and meticulous help with the texts, the images and copyright clearance. And for her very enjoyable and gracious good company throughout.

Helen Shenton
Librarian and College Archivist

First published in 2020 by
Scala Arts & Heritage Publishers Ltd
10 Lion Yard
Tremadoc Road
London SW4 7NQ, United Kingdom
www.scalapublishers.com

In association with
The Library of Trinity College Dublin
Dublin 2
Ireland
www.tcd.ie/library

ISBN 978-1-78551-242-1

Edited by Laura Fox
Designed by Linda Lundin, Park Studio
Printed and bound in Turkey

10 9 8 7 6 5 4 3 2 1

FRONT COVER:
The Book of Durrow
(see pp. 14–15)

FRONTISPIECE:
The Book of Kells
detail from folio 8r
(see pp. 46–47)

BACK COVER:
Long Room Gallery,
Old Library, Trinity
College Dublin